Knock John
Ship

ISBN 0-9539472-2-X
© Jardine Press 2001
Linocuts by James Dodds
Design by Catherine Clark
www.jamesdodds.co.uk

Knock John Ship

Compiled by James Dodds

Dedicated
to the crew of the Merker

Jardine Press
2001

Table of Contents

The Story of the Wreck on the Knock John, Christmas 1848, told through contemporary newspaper reports and personal accounts.

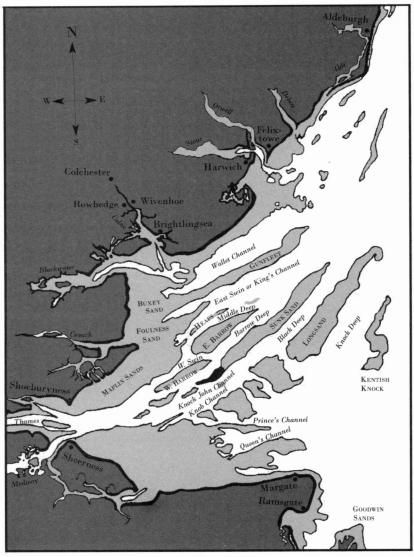

Map showing the treacherous sandbanks of the Thames Estuary.
The Knock John sandbank is shown in black on the south of the Sunk Sand.

HARWICH 26TH DEC — A large full rigged ship, on shore on the Sunk Sand, was boarded by the Scout Revenue Cutter, 23rd instant, when two goats and five pigs were found alive; her masts were all broken and lying across her decks, she had a full woman figure head gilded, painted ports, and is supposed to have been from Hamburg for Hong Kong, laden with a general cargo, some of which has landed here.

Lloyds List, 27th December 1848

WIVENHOE 27TH DEC — A large full rigged ship was seen two or three days ago, on the Knock John, and from papers found is supposed to be the *Merkur*, of Sondesburg, from Hamburg to Canton, it is feared all hands must have perished; som part of cargo has been landed here in a damaged state.

Lloyds List, 28th December 1848

Reports from the Receivers under the Salvage Act

Harwich 27th Dec:
Relating to sundries saved from the *Skylark*, on the Gunfleet, and from a vessel (supposed the *Mercur*, from Hamburg for Hong Kong) on the Sunk Sand; ...

Lloyds List, 29th December 1848

SHIP NEWS.—WIVENHOE, DEC. 24. —The Perseverant, of Brussels, from Nordenschluys for Jersey, grounded on the Maplin Sand on the 22nd inst., but was assisted off leaky, after throwing part of her cargo overboard.—The Equator, from Hamburgh for London, has been assisted in, after having struck upon the Holm Sand.—The Mercury, of and from Sunderland for London, got on the Gunfleet Sand last night, but was assisted off leaky.—A vessel, supposed to have been laden with potatoes, struck on the Gunfleet soon after the Mercury, and became a wreck; no account of the crew.—Dec. 25th.— The schooner Express, of Blankenese, from the Elbe for Bristol, has been assisted off the Maplin Sand.— **December 27th.—A large full-rigged ship was seen two or three days ago on the Knock John, from papers found supposed to be the Merker, of Sondeburg, from Hamburgh to China; part of cargo landed in a damaged state—were supposed to be lost.**

Essex Standard, 29th December 1848

Reports from the Receivers under the Salvage Act

Wivenhoe 10th Jan:
Schedule of articles saved from the wreck of the *Mercur*, on the Knock John.

Lloyds List, 11th January 1849

HARWICH

We briefly recorded last week the loss of a large vessel on the Sunk Sand, near this port, with, it is feared, the whole of the crew, no tidings having yet been heard of them. The following are the particulars as near as can be ascertained: The crew of her Majesty's Revenue Cutter, Scout, Captain Saxby, cruising off this port, on Friday, at about 8 30, p.m., heard the reports of guns and soon perceived lights in the direction of the Sunk Sand; the signals were answered by blue lights and cannon from the Scout, but the vessel being on the opposite side of the sand it was from five to six hours before the Scout could get alongside; she proved to be a foreign vessel, supposed Danish, of from 800 to 1000 tons burthen, but was deserted by the crew, laden with a general cargo; and from the direction that was on the packages brought on shore by the scout and other smacks, it is supposed that she was from Hamburg, bound to Hong Kong. At day break on Saturday morning Captain Saxby made a diligent search in all directions for the crew, but we regret to say without success. It is supposed when the signals were answered by the Scout the crew (from 16 to 30) took to the boats, and must have been swamped by the the heavy lea which was running at the time. part of the cargo which has already been brought on shore consists of Berlin wool, eau de Cologne, musical instruments, cutlery, broad cloths, &c., a large portion has been taken to Wivenhoe; the name of the vessel has not been ascertained.

Essex Standard, 5th January 1849

Captain Isaac Saxby
(1792 - 1872)

The redoubtable Captain Isaac Saxby of the Revenue cutters Desmond and Scout was in the early years of his service busy seizing smugglers, but when he died in 1872 at the age of eighty he was remembered as a life-saver. 'Many are the castaway crews he and his gallant Scout have landed at Harwich', ran the obituary in the Free Press. His best-remembered rescue was from the schooner *Hero* in 1844, when his efforts led for the second time to an outcry for a lifeboat . He must have earned good money as well as a fair reputation from them, for he had powerful craft and big crews provided at the Government's expense, and presumably the rewards for their endeavours were personal perks for him and his men.

From "The Salvagers"
by Hervey Benham

6

As an example of the scale of salvage work in this period, on the 25th October 1840 the schooner *Ariel* went ashore on the Gunfleet. 226 men were involved salvaging a cargo of tallow and hemp valued at £11,371. The *Scout* and forty-five smacks joined with a salvage claim. In 1849, 150 men were engaged in pillage of the Brig *Fleece* that also went ashore on the Gunfleet. 28 smacksmen were later charged. The *Scout* and four smacks made a claim on salvage brought in by 'wreckers' and were awarded £300. From 1840 to 1850 there were 170 vessels recorded salvaged or wrecked in the Thames Estuary.

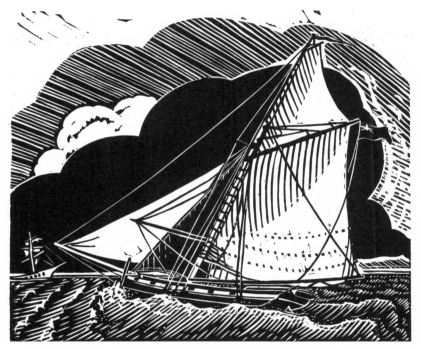

Revenue Cutter

It was not untill 1876 that Essex got it's first RNLI lifeboat the *Springwell* stationed at Harwich. This was the result of the international outcry at the tragic loss of 60 lives on board a German emigrant ship the *Deutschland*, wrecked on the Kentish Knock, in December 1875. 150 lives were saved by the steam paddle tug *Liverpool*, but there was public shock at the delay in mounting the rescue and accusations of pillage were made against 20 smacks. In 1890 Harwich got a second lifeboat station with the steam powered *Duke of Northumberland* with the necessary power and range.

The Story of the "Knock John"

from the notes of Albert Aldous Jefferies

About fifty years ago, a full rigged ship was wrecked in the late winter time, and the crew and passengers (if any) were totally lost.

She had on board a general cargo of all kinds of merchandise, and was from Hamburg, bound out it was believed to China, or somewhere in the far east on a bartering expedition, and had the greatest variety of articles ever known on one ship in the history of wrecked cargoes in the district.

She had gone out of her reckoning probably through the inset current. The story which follows came from a very old man who was the first person on board after the crew had left and this story is as near as I can remember it.

She were fitted out for sto'boating, sprat fishing, he said, working in the Thames Estuary and we had three other vessels about our class as partners. Each vessel carried a crew of five hands all told, the smacks being of the burthen of 30 tons.

We sailed from Brightlingsea after a hard gale had been blowing from the east-'ard and went up Swin to Shoebury Knock, just below Shoebury Ness, north side, and seaward entrance to the River Thames.

We there found 13 ships mostly colliers with coals for London ashore on that sand, so we stayed there sometime, and those that had not become derelict, full of water, and what we call dead'uns, had employed tugs to assist them, this being a comparatively sheltered bank near the entrance to the Thames proper, and therefore there were plenty of tugs about, and not much risk so far as life was concerned.

We found that our services were not required and as it was still blowing fresh with the wind right in from the sea, making rough weather everywhere in the Bay, and consequently too much sea in the channels of the Thames Estuary where we usually fish, we beat down Swin under close reefed canvas, and brought up in the bight of the Barrows Sand so as to be in a good place in case of anything amiss more seaward, or, as we say "lower down". *(See map: route 1.)*

Although it was rough and tumble riding in such weather, the wind continuing to blow hard from the east'ard, yet we had good ground tackle and we were accustomed to having "rolls for breakfast", so we didn't think anything of it, but set the watch with orders to keep a sharp lookout all round and report anything to the skipper should signals of distress appear from any part of the horizon.

A little before mid-night and just before the middle watches were changed, our lookout man went to the skipper and reported that right away to the southward of us a very big light was being exhibited, and from the size of the glare, he believed it to be a tar barrel burning.

The skipper turned out, and made it out to be as reported, concluding it was a ship ashore or in trouble on the south side of the Barrows, or on the Knock John, the next sand south of the Barrows, and made all arrangements to be underway as soon as possible.,

The weather was still the same, blowing hard easterly.

We accordingly got under way with our smack and beat down to windward and about day light brought up again and came to anchor nearer the Heaps Sand, [older name for the northern part of the Middle Sand] where was but precious little shelter and when it was fully day light, we could see the ship from which the

signals had been given by means of burning tar barrels, always a sign of great distress at sea.

During the forenoon of this day, the tide being out and the wind still up easterly, it was impossible to get round below the sand; but the weather was remarkably clear, so that from where we were riding at Heaps, we could see the people on the starboard side and quarter of the stranded vessel, making signals by means of a large flag on a staff. The seas were striking the ship on her stern and port quarters, and breaking clean over her hull, but as the Barrow Sands were between us, and it would be a considerable time before we could anyhow reach her with our smack, we waited until the tide had flowed a bit, so that the breakers on the sand were less formidable.

The high water was about noon or a little past, and we were most anxious to make the attempt to get across the sand to render assistance to those on the ship.

The seas continued to sweep her more heavily as the tide rose, and on board they had cut away all masts, and the sails, yards and gear hung in the greatest disorder over the starboard side.

Well, we made up our minds that we would make the attempt to cross the Barrows in our smack's boat and try to rescue the crew. *(See map: route 2.)*

The skipper and 3 men got into the boat, taking with them the storm lug sail. The wind being short and the tide running hard to leeward, we could not use this in getting out, so we had to pull with the oars in the teeth of the gale and current.

We were about half way across Barrows towards the ship, when we found that the seas and currents were taking us onto the High Knock of the sand, and that in a very few minutes we should be amongst the breakers, where the sand was almost dry.

That we all knew meant certain and immediate destruction. Thus we were compelled reluctantly to return and shipped the mast, setting the lug sail double reefed. This kept the boat ahead and clear of the breakers.

We got as far back as the north edge of the Barrows, and almost through the broken water, when the mast suddenly carried away, taking the sail with it to leeward, and as nearly as possible causing us to capsize, and but for smartness in trimming the boat we should have been drowned, as there was no chance of rescue in such circumstances.

However, we got all snugged and taking to our oars just succeeded in gaining the smack which was still riding as we left her with one hand on board. After taking a bit of grub we waited till the tide eased, and then getting the smack under way with storm canvas set we went with our vessel across the flat of the Barrows in the east part. In crossing this bank and making towards the ship, we passed in the channel between the Knock John and Barrows, two boats in a damaged condition, and these we reckoned belonged to the wreck, and the people in attempting to leave her had evidently been washed out. We passed other flotsam, which evidently came from the vessel. *(See map: route 3.)*

The tide had turned by this time and although there was a terrible sea on the bank which we were then crossing with our smack, we succeeded in getting safely into the next channel, called Barrow Deeps, and proceeded up with a free wind to the north side of the Knock John sandbank, and sailing as close as we could get, had a good look at the wreck.

We then saw that she must have been a very fine and very beautiful ship, but not a living soul was to be seen on board.

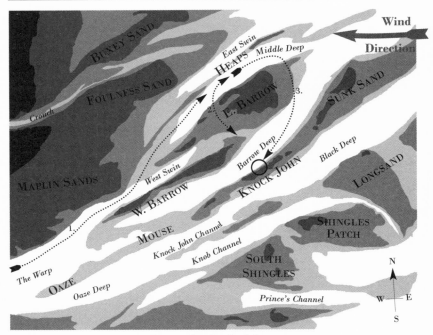

Route taken by the Salvers

Her head was lying towards the south west and she had a list to starboard, while all the masts and raffle wreckage were lying on the leeside.

We brought up our smack on the north side of the sand, three or four hundred yards off the wreck and prepared to board her in our small boat, the skipper and others of the crew as before leaving one hand in charge. The wind continued to blow in from the east'ard, very cold and there was plenty of sea still going.

We had the greatest difficulty in getting alongside of the wreck in our boat, as the wreckage was lying over the only side that we could board, owing to the confused sea, caused by afterwash and the downward current, and it required the greatest care to keep clear of the surging wreckage, which would in a moment stove in our boat.

However, we got close to her starboard side and the skipper and 2 more of the smack's crew scrambled on board as best they might. We had only fairly got on to the wreck, when another skipper and his crew from the next smack joined us.

Many other smacks of this class had been vieing with each other to see who could first get on board, and now the second skipper and our old skipper faced each other asking what was best to be done.

These two old salts went round the deck of the wrack, the tide in the meanwhile having ebbed somewhat and more of the ship became exposed. They could not find a single person on board, the only living things being a cat, a dog and a cockerel.

They observed that all the boats were away except a damaged one, which had sunk on the starboard quarter below the water and having pitched her stern on the sand was thus hanging on to the wreck.

They then went into the cabin, and here the second skipper remarked that someone must have been before them. Our skipper replied that this could not have been possible, as he had had the ship under observation before and since the crew left her, and that the valuable cabin furniture plate etc. which they were expecting to find, had probably been taken by the crew into their boats. He had moreover seen two large whale boats, evidently from this ship, drifting in a damaged condition bottom upwards.

It was after the lapse of more than a week, during which the salvers had been at work, whenever the weather permitted, that the cabin valuables were found in quite a promiscuous fashion.

One of the boys in charge of another vessel saw something shining at the wash of the sea, and on examination they found the cabin effects in the bottom of the boat which was hanging over the quarter of the wreck, or at least such of it as had not been already washed away.

We proceeded carefully to explore the cabin as far as the water would allow, and came across a quantity of unblocked beaver hats or as we put it gentlemen's "long sleeve bell toppers", all packed one into another.

Large quantities of ladies hats and head gear of different kinds were stowed away in like manner, and then we tumbled upon a lot of small French brass clocks in oval covered glasses, packed beautifully in wooden cases, a dozen in each case. These we placed in our own boat alongside the ship, they were most of them dry and had been kept in the top part of the cabin house.

When this was done, the crews of other craft in the neighbourhood got on board, but our partners before mentioned had not yet arrived. On it being proposed by one of the skippers then present for us to join in partnership, we declined saying we expected our own party there before long.

We had no sooner said this than an unlucky sea broke under the lea of the wreck, where our boat with one caretaker was placed, and it sent her on to one of the gallant yards alongside the ship, ripping her side out. The man on board had to be smart in getting into one of the other boats, for she sank almost immediately with the clocks and other contents, and our little boat was smashed up among the wreckage.

Seeing this calamity, we had to make a virtue of necessity and accepted the proposition to join in the salvage with the skipper whose boat was uninjured, and as the weather might come on bad at any moment so that we should be compelled to leave in order to save our lives, this partnership became desirable for obvious reasons.

After this we went to the main hold, and found it full to the hatches with cargo which we were there to salve, or as much of it as we could get while the opportunity offered, as the gale might increase and the wreck break to pieces, and all the contents wash out to sea, this sand being one of the most exposed and open in the Bay.

We found on removing the hatches that they were blocked by large wooden cases containing pianos. We had no time to remove these nor gear or appliances at hand, the masts having been cut away so there was nothing left but to "up axes", and break them up out of the way, to get at the more handy part of the cargo below. This was soon done and "how they did boom as they were knocked to pieces"!

With these out of the way we found in the main hold, bolts of cloth of various colours and quality, including splendid scarlet cloth, evidently for military purposes. When we had broken a bit into the hold we came across immense quantities of cheeses, each packed in a separate case and stuck on top of the cargo, clear of the main hold hatchways, under and between the upper deck beams. In other parts too were small cases and hampers packed with cordials, liquers, champagnes, all kinds of wine, spirits and perfumes, whilst below again under the hatchways, were large quantities of gunpowder in small barrels.

As salvage was proceeding, not in the most orderly manner, we who were first on board were joined by men from other smacks of the entire neighbourhood, the weather coming a bit finer in the evening and during the night. The cases of liqueurs were placed on deck for removal in the small boats when the rush came, and the men for the most part tackled the spirits, they also broke and smashed a good many things needlessly and scattered a good deal of loose gunpowder out of the barrels, some of which was quite dry.

It was then a terrible sight. Many of the men were mad with drink and otherwise excited amongst this fanciful and valuable property. Large casks were brought up holding drums, inside of which were packed all kinds of brass instruments, disjointed for stowing away. While some of the men were working properly, others roamed about in the most disorderly fashion.

Our old skipper cautioned all his crew against this danger. He said to one stranger who,was working near him. "I say mate, don't take your candle out of the lantern, as there is a lot of powder lying about, and it might soon make a mess of all hands". The answer is too terrible to record. A description of further like doings on the wreck that night is better left unattempted,

The clearing out of the ship lasted some four weeks, as the weather only allowed of operations at certain times, and the news of the celebrated cargo was of course "noised abroad in the regions round about". Boats of all sizes and varieties came from the different parts between Orfordness and North Foreland. The cargo gave up, in cases, guns of every description and make, both fanciful and useful, pistols, swords daggers of various kinds, rolls of silk, tons of roughly made pocket knives, bags of shot, bales of, cotton goods in great variety, china, Venetian glass, chimney ornaments, quantities of tumblers, decanters and wine glasses, oil paintings on copper plates, silver topped smelling bottles, tons of beads of all sizes, ladies silk handkerchiefs and hosiery.

In the lower hold was spelter, coils of new rope but, to enumerate all that ship had in her would take hours, it was common enough to say that she had everything except a pulpit.

There must have been one lady at least on the ship, perhaps the captain's wife, or the wife of the super-cargo as one of the smacks which arrived at the depot of the Receiver of Wreck (Board of Trade) had recovered from the ship a piece of unfinished needlework of the most delicate kind, worked on fine canvas with small beads. This needlework was examined by one of the officers of the Crown who had been sent from London to assist the local Customs and other authorities on this occasion, and he pronounced it very valuable.

The subject was Ruth gleaning in the fields of Boaz and the beads were with it to complete the work.

It was lying on the smack and had been used as a screen to keep in the smoke of the stove below. It was taken to the warehouse, but what eventually became of it is not known.

During the progress of clearing out the wreck, the master and crew of a certain smack had been working all through the night, and by the next morning were all exceedingly thirsty. There was no drinking water on board, and their smacks were some distance off, so they kept hoping that a case or hamper of wine would be brought up by their boat hooks, when at last came up what appeared to be the very thing, a case of champagne.

There it was, with the bottles all wrapped in paper and the skipper at once undid one and without more ado knocked off the neck with his axe. He gave the contents what he called a "right good swig", but finding the beverage had a queer flavour, he took the bottle from his lips and in so doing he spilt a little on deck. The colour was not that of champagne but of a much darker hue and he had the presence of mind to fetch the lot back from his throat by a very primitive method. It was blue ink!

A similar incident occurred on another boat. One of the young apprentices carefully concealed what he reckoned to be a bottle of good stuff, and when the smack was cleared he got out his bottle and knocked the top off with his clasp knife. A very small quantity was in this case sufficient, one mouthful and, he began to howl and caper. It was spirits of turpentine! His mouth was badly burned but he did not hear the last of that pull at the bottle for some time.

Towards the finish of clearing the wreck, the decks were strewn with straw and debris from the packages of the cargo, and there was a quantity of Stockholm and other kinds of tar in barrels.

One night, someone, out of pure mischief made a fire on deck with some remnants of the barrels, and when this was nicely alight threw on a keg of gunpowder. This happened to be saturated with sea water, and before the fire could get hold, another fellow rushed in and pulled it off, in pursuance of this kittenish pastime!

It will be readily understood that the greatest confusion was created in all places where the cargo was landed, and although the authorities of the time did their best to control matters it was an impossibility.

So many boats, people and places were engaged in this exciting business that the disorder continued from the first night until the finish, even afterwards a good deal of bad blood was engendered, and resulted in a big riot at Brightlingsea in the High Street, between the roughest of the men who had secured some of this property and the Officers of the Crown.

A free fight took place all round on that occasion, and both sides got a lot of broken heads and noses, though fortunately, one may say marvellously for the writer was an eye witness, no lives were lost in the melee. A local rhymster of the time composed some doggerel lines setting out in about twenty verses, the story of the riot. These were very pointed and quaint.

This notorious wreck and its cargo have ever since been spoken of as the Knock John ship, and past events of this neighbourhood are even now referred to as having happened before or after the time of the Knock John.

Hardly anyone engaged, really profited by the business, as other work was neglected, but many queer tales are told of how some of the lucky ones made exceptional finds and lay low over them.

From father's notes (Signed) K.J.
(Katy Jefferies)

Albert Aldous Jefferies
(1841-1924).

Albert wrote down the story of wreck on the Knock John saying it "came from a very old man who was the first person on board after the crew had left and this story is as near as I can remember it". Albert is unlikely to have been personally involved in the salvage of the *Mercur*. He would have been only 7 years old in 1849. Although he writes at the end of the story that the "writer was an eye witness to the riot". Perhaps Albert's notes are from the memories of his father Thomas who was appointed Water Bailiff in 1824. Both men were Oyster Merchants and lived in Brightlingsea's High Street. Albert was also recorded as a builder of yacht gigs and boats and as the Brightlingsea Lloyd's Agent for 42 years. As Lloyd's agent he had some authority in the matters of Salvage. He spent a perilous night marooned aboard another wrecked vessel the *KronPrincess Louise* while supervising her salvage. She was later refloated and towed into Brightlingsea.

Albert Aldous Jefferies was related by marriage to the Brightlingsea ship building family Aldous, as his name shows. (A boatbuilding member of the family returned the compliment with the name Albert Jefferies Aldous). Albert was also Secretary of the Brightlingsea Smacks Insurance Co for 28 years and wrote various articles for the *Wide World Magazine* in 1908, one concerning a skirmish between Harwich and Brightlingsea stone dredgers in 1853 in which his father was involved. Other articles concerned the running down of the stowboat *Express* by a steamer in 1898 where Albert successfully acted in his role as Secretary of the Brightlingsea Smacks Insurance Co in finding the steamer involved.

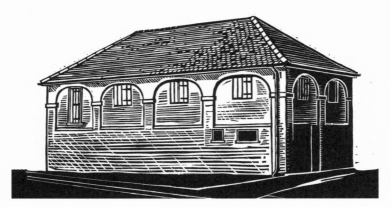

The Wreckhouse.
Inscribed on the front: "Cinque Port Board of Trade Wreckhouse". Later moved to Sydney Street with the same inscription. (E.P. Dickin)

Serious Affray

BRIGHTLINGSEA

On Tuesday last a somewhat serious disturbance took place at B.C. arising out of a search for wrecked property, supposed to have been secreted by the finders instead of being delivered up to the Customs House authorities. It will be recollected that in December last a large vessel was discovered a wreck on Gunfleet Sand, all the crew having been drowned. She was bound from Hamburg to Hong Kong with a very valuable general cargo, consisting of musical instruments, toys, wines, cutlery, guns, pistols, broad cloth, Berlin wool, eau de Cologne, &c. Besides the immense quantity of goods landed by the revenue cutters and smacks at harwich, Brightlingsea and Wivenhoe, the coast for several miles was strewed with the lighter description of articles, a large portion of which were picked up and appropriated by the finders. To recover some of this property, as well as other that were suspected to be secreted by some of the smacksmen, the coast-guard officers at Brightlingsea obtained a writ of assistance, and on the above day Mr. STEPHENS the chief officer and two of his men and policeman Trubshoe searched the houses of several suspected parties, in the course of which they seized a bale of cloth and several bottles of Champagne. Meantime the house of a woman who, it was supposed had given information to the officers, and had consequently become obnoxious to the sea-faring population of the village, was surrounded by upwards of 30 men and boys, who fired off guns and pistols, accompanied by hooting, yells, and other discordant noises. Through the midst of the tumult the officers had to pass with the recovered property; and, though the reception given to them was any-thing but gracious, it is probable no attack would have been made had not one of their number espied in the hands of the mob a pistol, which he imagined to be part of the wreckage in question, and which he instantly attempted to seize. This was resisted by the holder of the weapon and several of his companions, more of whom took the same side, when the other officers endeavoured to assist their companion. The scuffle soon came to blows, and after some time the officers, being the weaker party, were compelled to beat a retreat. As it was feared there would be a renewal of the disturbance, steps were taken to obtain further assistance, and on Wednesday Supt. McInnes, of Thorpe, and Supt. Brown, of Colchester, each with two or three officers, repaired thither. Fortunately, however, their services were not required; and it is hoped that the popular feeling will not again vent itself in a similar manner.— The matter will of course be submitted to the custom and police authorities, and it is very probable some of the parties concerned will be proceeded against for assaulting the officers, if not, in any other shape.

Essex Standard, 26th January 1849

15

COLCHESTER CASTLE

Saturday, Feb.17.

Before T. L. Ewen, Esq., (Chairman),
Rev. J. R. Smythies, George Round,
and E. Brett, Esqrs.

The recent Assault upon the Custom-house Officers at Brightlingsea.

Daniel Day and *George Minter*, mariners, of Brightlingsea, appeared to a charge of assaulting Robert Bounden and Charles Wisdom, commissioned boatmen at the same place, whilst in the execution of their duty on the 23rd of January last.

Mr. J. S. BARNES appeared with Mr. RAGGETT, the comptroller of customs at this port, on the part of the prosecution; and Mr. H. S. GOODY conducted the case for the defendants.

Mr. BARNES stated the circumstances of the case, observing that had not the assault been of so gross a description the Board of Customs would not have directed a prosecution to be proceeded in. He then called Mr. Benjamin R. Barnes, tide surveyor of this port, who spoke to seeing the complainant Bounden twice knocked down by Day; at the time of the scuffle he charged several persons in the crowd to aid and assist in rescuing the officers from ill-usage, but they refused to do so.

Cross-examined by Mr. Goody—The writ of assistance was sent to me; I never heard the principal officer, Mr. Stephens, say that Bounden was in fault; I believe the writ had not been executed until I arrived at Brightlingsea.

Mr. Charles Stephens, chief boatman in charge of St. Osyth Station, deposed.—On the day in question I had a writ of assistance in my possession, which had been directed to me; in company with the other custom-house officers, Bounded and Wisdom, and the police-officer, I entered several houses in Brightlingsea in search of wrecked property; in one house we found 13 yards of woollen cloth and two bottles of champagne; having finished the search between four and five o'clock, we were proceeding with the property towards the station; as we then heard the firing of pistols, one of the officers asked me if they saw any of the pistols belonging to the wreck whether they were to seize them; I replied that they were to do so; I myself walked nearly through the crowd which had collected in the street, without any interruption, but hearing a noise behind me I turned round, and saw Bounden at a short distance scuffling with another man; I immediately went in his assistance and saw him repeatedly struck by some one, but I don't know who; I saw the pistol which the officer was endeavouring to get from a man in the crowd, but I cannot say whether it was one taken from the wreck; did not see Wisdom struck; it was necessary for these officers to go through the crowd in order to reach the station.

Cross-examined by Mr. Goody.—No resistance was offered to my searching the houses; I have never said there would not have been any row but for that fool Bounden; what I sid say was "If Bounden had come through the crowd as I did there would have been no row;" I am not aware that there was anything said by those in the crowd reflecting upon the officers, but I heard a great deal of talk; there was a general rejoicing in the street with guns, pistols, "fiddling," and a woman on a donkey—{laughter}—but I don't know who else represented; Bounden was several yards from me, therefore I could not tell what passed between him and the crowd before I observed the scuffle; I did not tell Bounden to go round by Water Lane in preference to passing through the crowd; but I afterwards said I would willingly have gone through the lane had I known that the row would have occurred; to my knowledge I have not said a word to any individual blaming the conduct of Bounden. {Hisses and confusion.}

{It was here observed that persons standing behind the witness had been prompting him in his replies; and

Coastguard Station, Backwaterside Lane, Brightlingsea

Mr. BARNES applied to have all the witnesses in the case removed from the Court until called for.—This was acceded to by the the Bench, and the witnesses accordingly left the Court}

Cross-examination continued.—I consider Bounden was acting right in taking the pistol if he could have got it; I did not hear him offer to fight for a sovereign, nor did I see him take his coat off; I do not think there would have been any disturbance if this pistol had not been seized.

Robert Bounden, one of the complainants, said—As we were proceeding to the station with the goods we had found we had to pass through a crowd of between 300 and 400 people who were assembled, armed with fowling pieces, muskets, pistols, and bludgeons; whilst pursuing my way through the crowd, a man named Maskell fired a pistol over my head, and, in accordance with the instructions I had received from my superior officer, I mattempted to seize it, believing it to be part of the wrecked property; I succeeded in keeping possession of it for fifteen minutes, during which time I was repeatedly struck by the defendant Day. At length James Minter said— "You __! I'll knock your __ brains out, and we'll have your life at some future time if you don't give up the pistol" I considered my life would not be of much use to me after my brains were out—{laughter} so I gave up the pistol, the officer present also advised me to my course; the parties standing round were charged to aid and assist but refused; I had marks of violence on my person for a fortnight afterwards and feel the effects of the assault to this day; I still believe that the pistol I saw was one of those taken from the wreck.

Cross-examined.— I do not suppose the pistol was fired at me, as I was some yards off; there was no violent language towards me prior to taking the pistol nor did I up to that time see any violence offered. I do not know whether the crowd generally were troublesome or riotous; Minter struck me twice after the pistol was delivered up; there were 20 or 30 what I call respectable parties in the crowd but I've not requested one of them to come here and speak to my ill-usage for they are all tied by one string.{laughter}

By Mr. SMYTHIES. I had previously been handling a great many of the pistols from the wreck, and therefore I was able to distinguish them from others.

Mr. GOODY said supposing it were a part of the wrecked property he should prove that they were not justified in seizing it.

Mr. SMYTHIES remarked that there could be no doubt the seizure was a very unwise one.

Charles Wisdom corroborated the evidence of the last witness, and said the pistol very much resembled others that he had seen on the wreck.

Cross-examined. No attempt was made to take away the cloth; did not hear Minter say to Bounden "You had better be quiet;" he (witness) did not say "I expect we shall get a good smack of the head through your folly." Did not know whether these people were armed for the purpose of defence or otherwise. After the scuffle was over the village was quiet.

Police-constable Charles Trubshoe deposed that after the search with the Custom-house officers was completed he heard there was a row in the street and he accordingly accompanied Mr. Stephens through the crowd; when about half way through he observed a scuffle, and saw both Bounden and Wisdom struck; he advanced to interfere, but he was struck several blows, and at last was compelled to defend himself with his truncheon, and with some difficulty go quit of the crowd.

Cross-examined by Mr. GOODY.— Before they entered the crowd they were told that the people were firing off guns and pistols, but they had not then seen the pistols; at that time Mr Stephens said "we must secure those pistols;" before he had seen them he did not hear anything said about wrecked pistols; some of the crowd were three-parts drunk, and he (witness) recommended Bounden to give up the pistol and leave the crowd. It was in consequence of this seizure that the scuffle commenced.

This was being the case for the prosecution.

Mr. GOODY requested that the information upon which the defendants were first apprehended might be read over; he believed the offence was there described as an assault upon the officers "in the execution of their duty."

Mr. HOWARD, the clerk, accordingly read the information, which was to the effect stated, and

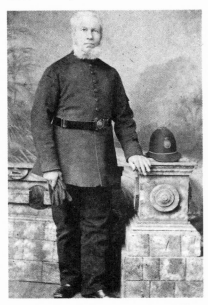

Brightlingsea's first Police-Constable,
Charles Christmas Trubshoe

Mr. GOODY then addressed the Bench on behalf of the defendants. He said Mr. Barnes in stating the case had not attempted to bring any law before them which could at all affect it; and upon the best of reasons—that he dare not do so. The circumstances must, he was sure, be quite clear to the Bench. There was a general rejoicing among the inhabitants at the disposal of the wreckage of a ship which had been unfortunately cast upon the shore; he said "rejoicing" because it was his friend Mr. Barnes's own expression, and indeed there was nothing else until this unfortunate collision took place with the officers; and in order that this case should be sustained it would be necessary for his friend to show that

these officers were in the execution of their duty. They were about to rescue a pistol which they believed to be part of the wreckage, and he thought Mr. Barnes could show no point of law which would justify such a seizure under the circumstances which had that day been brought before them. It was not because it was thought to be a wrecked pistol that the seizure was made, for the police-constable, who was the only witness that had given the true version of the story, had told them that before they had seen the pistols, and no sooner than they had heard the report, the officers had determined amongst themselves to suppress it, and said "we must put down those pistols."

Mr. BARNES.—He has not said so.

Mr SMYTHIES believed the expression was "we must have these pistols."

Mr GOODY.—At all events it was a preconcerted thing on the part of the officers that they should try to suppress the disturbance, and take away the pistols.

Mr. Barnes.—No, no; the officers had not a thought of such a thing.

Mr. GOODY then directed the attention of the Bench to a recent Act of Parliament, which provided that in case of any person assaulting an officer of customs or excise in the due execution of his duty should be liable to transportation for a term not exceeding seven years. That was the misdemeanour with which his clients were charged. It had been brought before them in evidence that a vessel had been unfortunately wrecked off the Essex coast, and that this pistol was part of the wreckage. But there was nothing to justify the seizure supposing it was wrecked property; for the Salvage Act enacted that where a person should be in possession of any wrecked property he should forthwith send it to the receiver or comptroller of customs near to the place, in default of which he rendered himself liable to a penalty of £100. This was the penalty to which the defendants had rendered themselves liable had the proper course for its recovery been adopted. But another clause of the same Act provided that in case any party should seize and retain possession of any article which had not been duly reported, it should be lawful for the receiver or other officer of customs to go before a Magistrate and lay an information, upon which a warrant could be issued for the apprehension of the party so offending. There had been no such proceeding against these individuals; and he (Mr. Goody) contended that there was no law whatever which would authorize them in convicting or sending for trial a case of this description, in which there was nothing in the Act to justify the officers in forcibly rescuing the pistol. Upon this point rested the whole case; for without this seizure the inhabitants would have been peaceful enough; and in a mass they would, if required, come forward and say that the officer had been guilty of causing a breach of the peace; and indeed it was the wonder of the whole village that the case had terminated so lightly as it had done.

Mr. BARNES in reply said in the first place he had shown that this wreck took place in the Knock John, a place within the Cinque Ports.

Mr. SMYTHIES said they had not yet had that proved.

Mr BARNES quoted the Act of Parliament, and submitted that the Act itself proved it.

Mr. GOODY wished it to be understood that he had witnesses in Court; and in case the Bench should decide against him on this point he should proceed to call them, but should his objection be considered good, as he thought it would be, then of course the case would at once fall to the ground.

Mr. HOWARD thought this course rather irregular.

Mr GOODY said his object was to save the time of the Court.

Mr. BARNES said the point would more properly be raised before a Court of Justice, when the defendants were upon their trial.

Mr. EWEN concurred in that opinion; the Bench were not to try the defendants.

Mr. BARNES then quoted the 56th sect. of the 8th and 9th Vict. chap. 86, relative to the duty to which the pistol in question was subject.

Mr. GOODY said Mr. Barnes must first prove it to be a foreign article, and subject to duty.

Mr. BARNES said they had shown that it was derelict, and they had not the pistol there to prove that it was foreign, but it was quite sufficient if they alleged it to be so. He confessed he never before witnessed the proceedings conducted in this way; he conceived they were merely there in order that the Bench might decide whether there was sufficient to send te case for trial at the Assize. He had shown that there had been a great many pistols of this description brought from the wreck to Brightlingsea; that a number of persons were on this occasion assembled in the street; the officers were proceeding through the crowd with some wrecked goods to the proper warehouse, when one of them seized a pistol which he affirmed to be, to the best of his belief, part of the wrecked property; for some time he retained his hold of the pistol, and he that day told them that he should have kept possession of it had it not been for a threat upon his life, which compelled him to give it up. He was violently assaulted, and if all that was not incurred in the execution of his duty, he (Mr. Barnes) did not know what was his duty. He submitted that the officer had a right to make the seizure, and so long as he was acting under the authority of his superior officer he was acting up to his duty.

Mr. EWEN said Mr. Goody had stated that an officer had a right to search a house, but he had no right to seize wrecked property from the person of an individual upon the public road. The Bench wished Mr. Barnes to address himself to that point.

Mr. BARNES.—Does Mr. Goody mean to say that if the officer were to see a man running with a bale of cloth, which he knows to have been wrecked, he has not the power to stop him?

Mr. GOODY.—Exactly.

Mr. BARNES said he did not seek to come under the Wreckage Act, but under the Cinque Port Act; and he contended that the very circumstance of these men having a pistol alleged to have been part of the wreckage stored, brought them under its provisions.

Mr. GOODY remarked that he had on a former occasion put Mr. Barnes out of Court under the Cinque Port Act, which would not avail him in this instance.

The CHAIRMAN said he could not see from anything Mr. Barnes had advanced that a person could stop a man in the public street with wrecked goods in his possession under a writ of assistance.

Mr. BARNES read the 146th section of the 8th and 9th Victoria, c. 86, which enacted that where the duty on goods had thus not been paid the same should be declared forfeited in consequence of the duty not having been paid, and that the officer was perfectly justified in what he had done. Supposing such was not the case, nothing whatever could justify the conduct of the defendants in ill-using the officers as they had done.

Mr. SMYTHIES remarked that Bounden was carrying nothing, and had not been touched by the crowd until he seized this pistol; it was quite clear they had exceeded their duty, as they ought to have come before them (the Bench) for a warrant to make the seizure.

Mr. BARNES said he should not offer any further argument, but must leave the matter in the hands of the Court, and he believed the officers were fully in the execution of their duty in the course they had pursued. Supposing Mr. Goody to have been defending the party who had this pistol this argument might hold good; but he thought nothing could justify the conduct of the defendants in the way in which they had assaulted the officers.

Mr. BAWTHER said he could fully understand that the officers were only executing their duty in carrying the goods through the crowd to the station-house, but he very much questioned whether they were not exceeding the limits of their office in thus forcibly taking the pistol.

The room was then cleared for a private consultation amongst the Magistrates, and upon re-admission being shortly afterwards granted,

The CHAIRMAN said upon a careful consideration of the circumstances

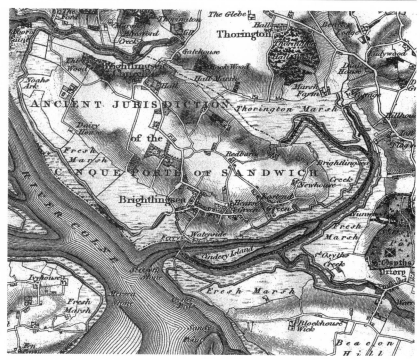

Map of Brightlingsea c. 1850

attending this information for an assault they were of opinion, from the evidence that had been adduced, that the attempt was made by the officer under the impression that the pistol was part of the wreckage. They were of opinion that the officer was not justified by law in making such a seizure, and they further thought that it was injudicious to attempt to seize the pistol under such circumstances. At the same time he felt it his duty, by way of caution to them in future, to tell them that they had had a very narrow escape of being sent to Chelmsford to take their trial at the assize. He did not exactly understand the occasion of this rejoicing in the village; but he had no hesitation in saying it was not very much to the credit of the inhabitants,

that because there unfortunately happened to be a wreck on their shore they should thus rejoice that they had seized, or in fact stolen, the wrecked goods. The Bench would now dismiss the case, leaving it open for the parties who brought forward this information to prefer a charge against the defendants for a common assault if they chose.

The parties then left the Court.

The case excited considerable interest; and during its hearing, which lasted nearly four hours, the Court was densely crowded with the mariners and other inhabitants of Brightlingsea

Essex Standard, 16th February 1849

Reefed down smack tacking back to the wreck

Knock John

By Uncle Webb, a Local Rhymster at the time

1

A certain gay lady drest all in her best,
Did through the Town ride and that on an ass,
And she being determined to have a day's fun
Set of the fair that is called the Knock John.

2

Attended by servants one two and three
And riding along being all in high glee,
But going along by chance did meet one
Saying why are you going to the Fair of Knock John

3

As you ask me the question and harken no doubt
The truth I will tell you how it all came about,
A ship in distress and the sand got upon
And that was the cause of the fair of Knock John

4

The salvers went out to this ship in distress,
To try for to save her and secure all the rest,
Having loaded their vessels they all sailed for home,
Bringing things on shore from the wreck of Knock John.

5

Arrived in the Creek at the Town of B.C.
Where many were waiting looking out for a fee,
The officers in boarding the Decks jumped on,
Saying we hear you are come from the Wreck of Knock John.

6

Now what is the Cargo we wish for to hear,
For we all do intend to come in for a share,
This hint being dropped the Salvers looking on,
Said Gin, Cloth and Brandy brought from the Knock John.

7

To secure what next followed will cause you to wonder
To see how the Parties were bent upon Plunder
For they seemed determined almost every one
To have a something brought from the Knock John

8

The Salvers, thinking no one had more right
To a share of these goods for they risked their life
So they went to work to remove the things home
That they might remember the Wreck of Knock John

9

Many goods were removed through the Town right and left
And many there were who tried all their best
To take something home their shelves to lay on
That was brought from the wreck of the sands of Knock John

10

But honesty here though lagging behind,
To trust a near neighbour there was some inclined
To allow him to take home some goods and so on
That they had worked hard for at the Wreck of Knock John

11

Not thinking that they were doing anything wrong
They expected when called for to have them returned
But upon application the very first one
Declared the things stolen brought from the Knock John

12

The parties concerned they now thought it hard
That they should be robbed of all their reward
Began for to murmer that they could not look on
The things they had brought from the Wreck of Knock John

13

At this stage of affairs it was whispered about
An informer there was who began for to spout
And she being angry with her neighbour for one
Declared she had things buried stolen from the Knock John

14

The same thing made known to the officers here
And they very quick on the spot did appear
And being very busy her own garden went on
And found the things buried stolen from the Knock John

15

So neighbours and friends, now pray don't you think
The name of informer a long time will stink
In the nostrils of those who the sand went upon
To try to save the goods from the Wreck of Knock John

16

Now all you my friends who hear me this day
I beg you will attend to what I now say
And I will confess that I was the one
Informed of the goods stolen from the Knock John

17

Now all you informers that live far and near
If you will attend you quickly shall hear
The lady found guilty and a Verdict returned
That she should be burnt at the Fair of Knock John

18

All you who have heard of this singular event
If you are an Informer I hope you'll repent
For fear like this lady you should be the next one
To burn in the fire at the Fair of Knock John

19

And now to conclude and finish my theme
The verses I've written are just nineteen
And I hope you'll consider the straight line to walk on
Then you'll never be afraid of the Fire of Knock John

LARGE AND IMPORTANT SALE

OF

WRECKED GOODS,

LYING AT THE

CUSTOM-HOUSE, COLCHESTER,

Admiralty Warehouses of the Cinque Ports, Wivenhoe and Brightlingsea,

SALVED FROM THE SHIP "MERCUR"

Wrecked on a voyage from Hamburgh to Hong Kong, Singapore, &c.;

SEVERAL thousand yards of superfine Cloths, Jewellery, Wine, Cordials, Eau de Cologne; 400 boxes of Glass, gold and silver lace, fringe, Glaziers' diamonds, musical boxes, Nankin, cotton, thread, hides of leather; stockings, socks, silk umbrellas, candlesticks, ironmongery, cotton drawers and shirts; brass instruments; butter, cheese, provisions, looking glasses, pictures, toys, bunting, tumblers, decanters, cutlery, brass wire, nails, steel spelter, &c., &c., &c.; which will be SOLD BY PUBLIC AUCTION, at the Custom House, on Wednesday, 14th; Wivenhoe, 15th and 16th, and Brightlingsea, 19th days of February.

Hand bills will be out, describing the whole of the Property, during next week.

Further particulars may be known on application to the Collector and Comptroller of Her Majesty's Customs, Custom House, Colchester; JOHN G CHAMBERLAIN, Deputy Serjeant of the Cinque Ports, Wivenhoe; or MR. BARNES, Tide Surveyor, Brightlingsea; or Captain HUGO, George Hotel, Colchester.

Further particulars in next week's paper.

Essex Standard, 2nd February 1849

Wrecked Goods, at Harwich.

TO BE SOLD BY PUBLIC AUCTION, BY

Messrs. Hales and Miall

(Who are jointly concerned in this Sale),

At the Clerk of the Check Premises, Harwich, on TUESDAY,
the 13th of February, 1849,

Part of the CARGO salved from the Ship "Mercur," wrecked on a voyage from Hamburgh to Hong-Kong, Singapore, &c.; comprising about 400 yards of superfine cloth, 100 bottles of cordials, 120 cases Eau de Cologne, 350 boxes of glass 4 musical boxes, 9 pieces nankeen, 14 hides of leather, 100 skins patent leather, 100 dozen socks and stockings, — dozen brass candlesticks, 80 carpenters adzes and hatchets, — dozen carving knives and forks, — gross of other knives, — cards of penknives, pencils, tooth-brushes, spectacles, tinsel, — lbs. beads, brass wire, nails, 60 cases steel, about 200 lbs. each; 10 cakes spelter, 6 pigs of lead, 20 tin cases of white lead and black paint, 8 kegs butter, 29 Edam and Gouda cheeses. 34 hams, 13 bolts of sail-cloth, 11 pieces painted floor-cloth, 230 pictures, 6 pier glasses, 132 dressing-glasses, 57 clarinets, — flageolets, brass key-bugles, brass trumpets, trombones, cymbals, sponge, 22 bundles cotton yarn, — bundles Berlin wool, — gross glass tumblers, decanters, candlesticks and lamp glasses, 97 kegs of gunpowder, 19 coils of excellent new hemp rigging cordage, Iron 8-inch to 2-inch cut rigging, &c., &c. ; the whole of which will be detailed in Catalogues, to be had of the Auctioneers, Harwich; and the goods may be viewed on the Saturday and Monday preceding the day of Sale.

Any further particulars may be known on reference to Mr. F. Hales, Deputy Sergeant of the Cinque Ports, and Messrs. Billingsley and Co., Agents to Lloyds, Harwich; or Captain Hooge, George Inn, Colchester.

Sale to commence at Ten o'clock in the Forenoon.

Essex Standard, 9th February 1849

CONCEALING WRECKED SPIRITS. —
At the Magistrates' Clerk's Office, on
Tuesday last, *John Jarred,* dredgerman
at Brightlingsea, appeared before
GEORGE ROUND, Esq., to an informa-
tion by Mr. Raggett, Comptroller of
Customs at this port, for having in his
possession a quantity of spirits, salved
from a wreck near the above place,
without the payment of any duty.—
Mr. J. B. BARNES appeared in support
of the information.—Charles Wisdom,
an officer of Customs, stated that he
knew the defendant well; on Monday,
the 22nd of January, whilst searching
his premises for goods subject to duty,
he found three bottles containing
Hollands and two of cherry brandy
secreted in a cupboard, both of which
were subject to duty; the quantity did
not exceed a gallon; he delivered them
to Mr. Raggett, the Comptroller of
Customs.—Mr. Robt. Raggett proved
receiving the above from the last wit-
ness, which contained together about
three quarts; it had been unshipped
without the payment of duty, and was
consequently liable to forfeiture.—In
his defence the defendant said the
property in question had fallen into his
hands, and was found in his house.—
He was convicted in the sum of £2.10,
including expenses.

Essex Standard, 2nd February 1849

Abraham Addison, mariner,
of Brightlingsea, was charged with
assaulting Wiliam Berber, of the same
place, and taking a pocket-handker-
chief from his person.—An arrange-
ment had previously been come to
between the parties, and defendant
was dismissed on paying the costs,
amounting to 11s. 6d.

Essex Standard, 2nd February 1849

ANOTHER ASSAULT AT BRIGHT-
LINGSEA.—*James Cook,* mariner, of
Brightlingsea, was complained against
for assaulting one Emmanuel
Fieldgate, of the same place.—Mr.
GOODY for defendant. It appeared that
the complainant having met Cook in
the street, the latter accused him of
having stolen some cloth—a portion of
the late wreckage: this was denied by
complainant, and the defendant
termed him a liar; complainant, in
retaliation, made use of the same
expression to the defendant, upon
which he (Cook) struck him upon the
head.—A man named Samuel Barber
was called for the defence, and stated
that the complainant was not injured
by the blow, and his hat was merely
knocked off.—By the consent of com-
plainant the Bench discharged defen-
dant upon paying 8s. 6d. costs, with-
out a conviction.

Essex Standard, 16th February 1849

Hervey Benham talking to Harry Bragg
in the Water Bailiffs Office, circa 1947

"I don't suppose anyone can go back to the Knock John ship?" I asked those ancient mariners, mentioning perhaps the richest of all the windfalls that an ill-wind ever blew ashore for the good of Brightlingsea and Rowhedge. That was in 1856, yet I was among men with long memories, and longer family traditions. "Well, seeing that I took my drop of medicine out of a Knock John glass just before I came here," said Bragg, "I dare say I ought to know something about it." And here he told me how his family had secured these glasses, one of which had been given as a wedding present at the time of every marriage in the family since, and how there were men in the town who secured the rich cloth aboard "and never did a stroke of work again as long as they lived," and how a woman who informed on the plunderers was burned in effigy.

(from "Last Stronghold of Sail" by Hervey Benham)

Afterword

What a fate! To be wrecked at the beginning of a long voyage with a hold full of riches, in a freezing winter storm. Spending the days before Christmas in misery, fearing that every minute was to be your last, only to perish after seeing and signaling to potential rescuers.

The Thames Estuary forms a funnel, a natural trap. Its wide delta of sand banks, with the set of the tide made it treacherous to unsuspecting south bound ships. The lights of the Kent coast were easily mistaken with the lights of the France. The Local fishermen had an intimate knowledge of the channels and sand banks and in their strong relatively shallow draught smacks, had the ability to rescue lives and salvage these stricken vessels.

An Act of parliament of George IV nominated Ramsgate, Deal, Dover, Harwich, Brightlingsea and Wivenhoe as places authorised for receipt of salvage. The Lord Warden of the Cinque Ports, The Duke of Wellington (1769-1852), claimed the 'Right of Wreck' at Sea from Harwich to Seaford. Any kind of wreckage that came ashore had to be turned over to the Receivers of Wrecks (the Deputy Serjeant of the Admiralty of the Cinque Ports) at the Customs House, and then auctioned for the benefit of the Lord Warden, Admiralty & Crown, owners & underighters, and salvers (the salvers getting around a third). However, it is perhaps understandable to try and keep goods that you have risked you life to save from a sinking ship.

A Wreck was defined in 1275 thus: 'A ship is not a wreck providing a man, cat or dog escapes from it alive'. It could be argued that this could have lead to unscrupulous salvagers laying off until the vessel could be secured as a derelict wreck, or worse . . . Unfortunately there was very little financial reward in saving lives.

This booklet is a collection of surviving information surrounding the Wreck on the Knock John from the following sources:

Essex Standard, Newspaper, at Colchester Library;
Lloyds List, at the Guildhall Library, London;
Hervey Benham's *Last Stronghold of Sail, The Stowboaters, The Salvagers;*
Dr E. P. Dickin's *History of Brightlingsea* & papers at Records Office Colchester;
David Higgins *The Beachmen*
Richard & Bridget Larn *Shipwreck Index of the British Isles;*
Nottage Institute,
Family papers.